CELTIC DESIGN

Aidan Meehan studied Celtic art in Ireland and Scotland and has spent the last two decades playing a leading role in the renaissance of this authentic tradition. He has given workshops, demonstrations and lectures in Europe and the USA, and more recently the Pacific North West from his home base in Vancouver, B.C., Canada.

CELTIC DESIGN

A BEGINNER'S MANUAL

AIDAN MEEHAN

With 258
illustrations

THAMES AND
HUDSON

Also published in this series
KNOTWORK:THE
SECRET METHOD OF
THE SCRIBES

artwork and calligraphy
Copyright © 1991 Aidan Meehan

Printed and bound in Great Britain

CONTENTS

Introduction

ERE for the first time is a
manual of Celtic design for
beginners which gives the
form of construction of
step patterns and key patterns
based on the hitherto secret grid
method of the scribes. This meth-
od is simple, a matter of joining
the dots.

Almost as simple is the freehand
construction of the spiral, given
here along with a selection of treat-
ments from early Celtic metalwork.

Compass work is also important
to Celtic design, and here it is com-
bined with the construction of
letters, the decoration of which
is suggested as an application.

TEP PATTERNS

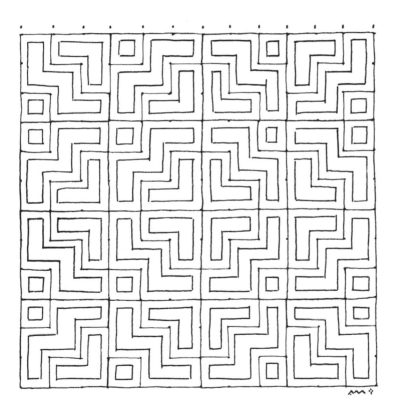

Step patterns, found in the illuminated books, metal- and stonework, are very sim- ple, and illu- strate the in- telligibility of form that characterises Celtic pattern. Here are a few examples for you to repro- duce.

a. Six·square grid.

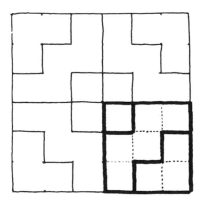

b. Same grid; each quarter is a three- square step pattern.

Usually the design is worked out on a simple square grid of dots in which repeats of a smaller unit may be arranged in different combinations as here, a, b, c, d. These patterns, b, c, d, are based on the smaller repeat, b.

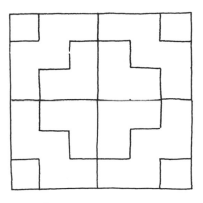

c. The quarters re-arranged.

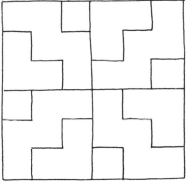

d. Same three-square unit in six-square grid.

[9]

a. This one is made of four units, each one based on a four-square grid. Together the four units fill an eight-square.

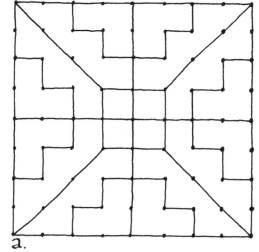

a.

b. If we change the order of the tiles, this is one result.

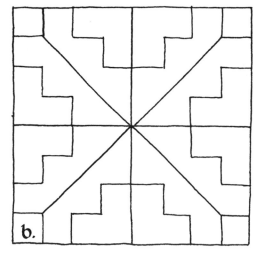

b.

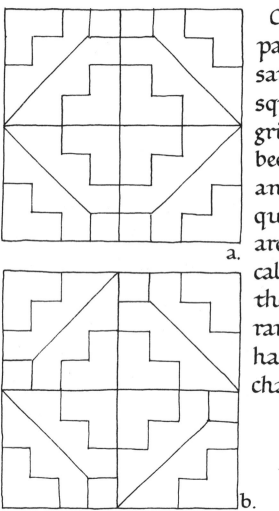

a.

b.

On this page, the same eight-square grid has been used, and the quadrants are identical. Only their arrangement has been changed.

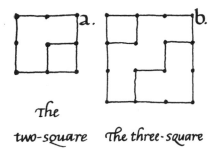

The
two-square The three-square

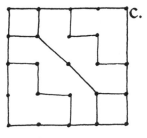

The four-square

 A GREAT many beautiful overall patterns may be produced by the tile method, as shown on previous pages. The three-square, b, is used on pages 8 and 9. The four-square, c, is a variation of the tile unit used in the patterns on page 10 and 11.

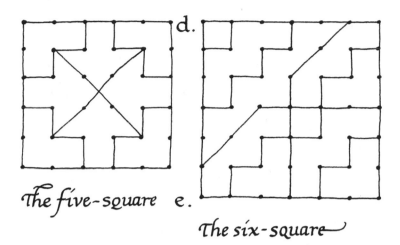

The five-square e.

The six-square

In these two we see the dia~
gonal line used, as on previous
page, c, to tie~in points on the
grid otherwise floating free of
the step lines. A single square
might also have been used to con~
nect the centre dots of fig.d.

PATTERNS are pleasing when they are reasonably well balanced. The two-square tile, a, below, is not balan-ced, yet four units make a very balanced pattern, b, that fills a four-square grid.

Three tiles will fit a six-square along each side, c, but the result is not a pattern. It is useful as a tile, though, and could be

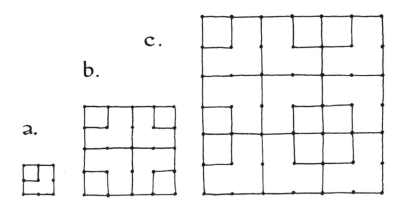

a.

b.

c.

arranged in each quarter of a
twelve ~ square dot grid.

 The pattern below is on an
eight ~ square grid, d. Each quar~
ter is the same design as that on
the opposite page, b, used here as
a tile. In the middle of the pat~
tern, d, a further tile unit em~
erges. Compare this unit, e,
with that at b. The respective
modules are shown at f and a.

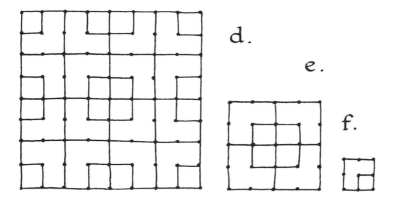

d.

e.

f.

 N this page, the three - square tile, *a*, is expanded to fill a six-square and a twelve-square lay-out.
Four units combine to form the six-square, *b*. In turn, four of these make up the larger square, *c*. The centre four tiles in *fig. c* provide a further variation.

On page 17, a four-square tile: compare with pages 10, 11.

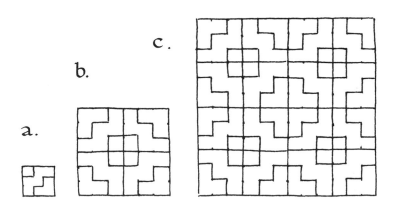

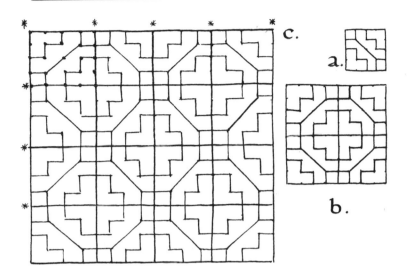

c.

a.

b.

N the manuscripts these step patterns are used as fillers, drawn freehand, or aided by a grid. To draw the grid for c, above, lay out the 4 x 4 squares in pencil, as indicated by asterisks. Then dot in the tile grid, as at top left, and ink in the lines, tile by tile.

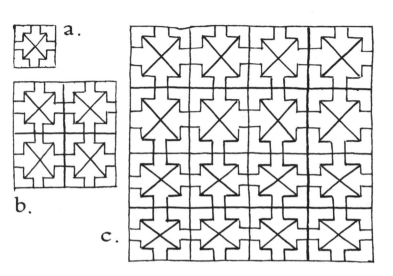

a.

b.

c.

ETALWORK is another art in which the Celtic artists used step pattern, this one from the Lemanahan shrine, Ireland, 12th century. The design above appears as an enamel stud. It joins all the dots of a five-by-five square grid. Repeated in four and sixteen units, b, c.

HIS beauty is showcased in the Book of Lindisfarne, in a major piece of work, one of the exceptions, for step patterns are usually neglected. But the type of design you see here represents a mature tradition in its bloom, a widely practised art form. It has been sadly overlooked, a fact that is

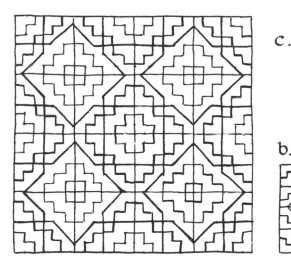

c.

a.

b.

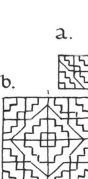

brought out by a search through the
manuscripts.. there are few of any
great, and a lot of very little interest.
So the whole class is often overlook-
ed, which is a pity. Master the step
patterns. They provide a key to the
metal smith's art of over-all grid
layout: this is the basis of Celtic
carpet-page design.

a.

b.

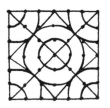

The pattern opposite, from the
Book of Kells, uses circles instead
of steps, but is developed from a
grid, nevertheless, a,c.

Below, from the Book of Dur-
row, a combination of circle and
step, derived from the six-square
grid, b.

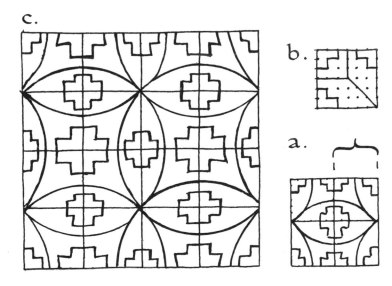

c.

b.

a.

 IG. b, on previous page has dots to spare that may be a. joined by step lines, a, then repeated, b, and outlined, c.

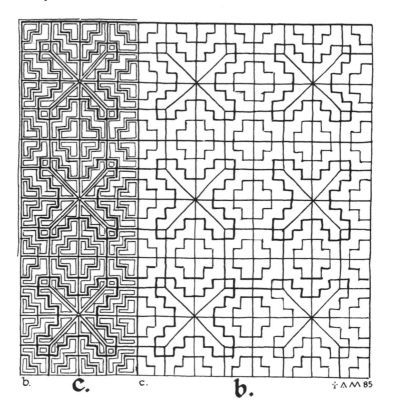

b. c. c. b. ᛏ∆ᛙ 85

KEY PATTERNS go well with other kinds of Celtic pattern. Here, borders of step pattern and plait work combine with the cross of key pattern.

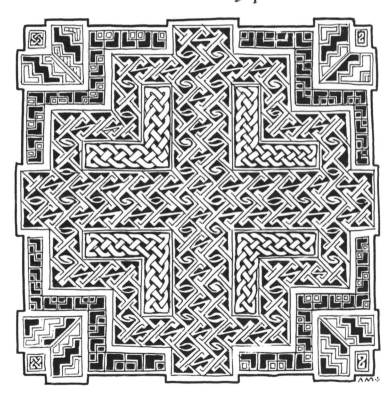

AS WITH STEP patterns and plaitwork, key

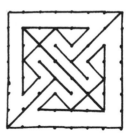

patterns are easily made by join-the-dots. As in plaitwork, the lines are placed in such a way as to create paths.

Fig. 1, a.

Fig. 1, b.

Key patterns are found worldwide. Celtic key patterns are based on a particular system, developed from a basic square building block, Fig. 1, b. The basic key pattern starts out on a square grid, 7 spaces across and 7 down, enclosed by the sides of a square. This box and these dots define the

Fig. 2, a.

Fig. 2, b.

pattern.

In drawing the pattern, the lines follow a certain order. This is called the stroke order, as illustrated on this and the following pages, Fig. 2, a ~ j.

The diagonals should be drawn first, Fig. 2, a, b. The first diagonal goes through the middle cell, but not the corners, Fig. 2, a. The second cuts through the corners, not the centre. Fig. 2, b. Next draw the "arrow-heads" on the ends of the first diagonal, Fig. 2, c ~ f.

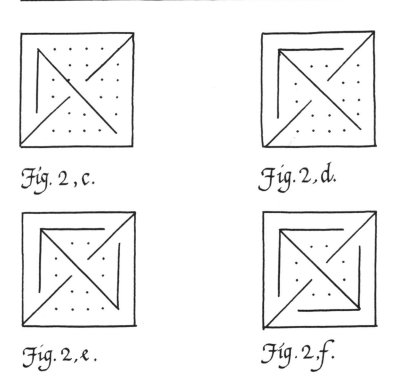

Fig. 2, c.

Fig. 2, d.

Fig. 2, e.

Fig. 2, f.

The arrow heads define the corners at each end of the diagonal stroke at fig. 2, a. This is why the corners must be avoided when drawing the first stroke, to accommodate the path.

[26]

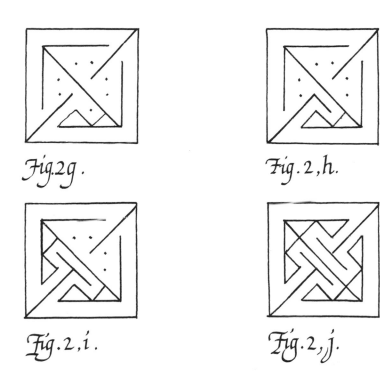

Fig.2g.

Fig.2,h.

Fig.2,i.

Fig.2,j.

On each arm of the arrowhead, draw a zig-zag, fig. 2,g, which locks the "key", fig. 2,h. Double the lock and key, fig. 2,i. Repeat diagon- ally opposite, fig. 2,j.

[27]

Chapter 11

.

.

.

.

.

.

.

.

Fig. 3, a.

 N THE FOLLOWING PAGES, all the designs of *figs.* 3~6 are based on the grid above, which has Thirteen spaces across, and seven down.

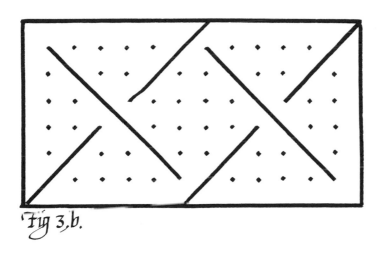

Fig 3,b.

On the grid lay the lines of the
diagonals as before , first the un-
broken stroke with a gap at each
end , as in *fig. 2a* , then the broken
diagonal , as in *fig.2,b*. Complete the
right-hand half of *fig.3,b* only after
having done the left side. Set off the
whole diagonal first, directly below
the intersection of the upper edge

[29]

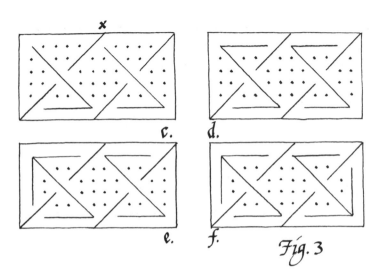

Fig. 3

with the broken diagonal already drawn, marked "x" above, *f*. 3, c. Check that the positions of the diagonals are exactly as in *f*. 3, b before proceeding. You can tell by the pattern of dots whether your lines are arranged correctly or not.

The next stage, the arrow-heads, includes two segments of path on

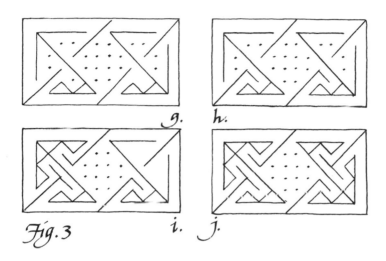

g. h.

Fig.3 i. j.

the upper and lower edge of the
rectangle, fig. 3, f. This completes
the second stage. Check the dots
to ensure lines are in order.

Third, complete the corners, fig. 3,
j. The keys are all aligned along the
edges. Only the centre diamond
cell remains. Notice the form of the
twelve dots in the diamond.

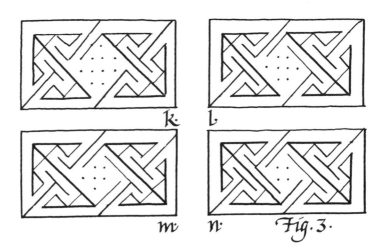

k. l.

m. n. Fig. 3.

There are quite a few variants that can be made in the central cell, but first, the swastika key pattern. In the diamond of fig. 3, j, you will see four paths leading into the space. Extend these paths, fig. 3, k–r, to form the clockwise spiral in the middle, in two stages. The first stage is shown here, k–n.

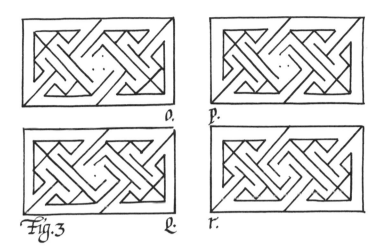

Fig.3

o.

p.

e.

r.

Make sure all four arms of the
spiral in fig. 3, n, are complete, and four
dots remain. Now wind a final turn,
as above, fig. 3, o – r.

The really significant part of this
pattern is the layout of the diagonals
and the keys around the edges and
corners. Master steps a – j, fig. 3, and
the following variations will be easy.

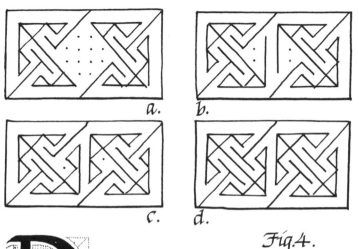

a. b.

c. d.

Fig.4.

RAW the grid as in fig.3, and complete steps a~j up to the diamond with 12 dots, as above, fig.4,a.

Now complete the two arrow heads with a single path width between, as in fig.4,b.

Last, complete locks first, fig.4,c. either side of the vertical bar, fig.4,d.

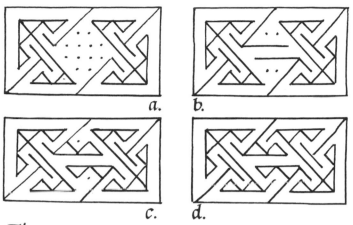

a. b.

c. d.

Fig. 5.

TART This keypattern with the
same build up as in the last
one, but, instead of a vertic-
al bar put in a horizontal,
as in fig. 5,b, consisting of two par-
allel lines each springing from a key.

On the lines of the bar, put the
zigzag lock, fig. 5c.

Complete key in each lock, fig. 5d.

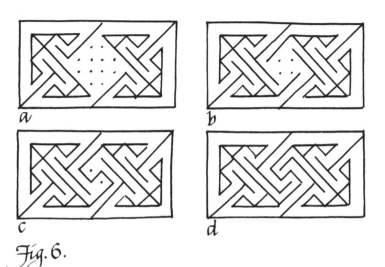

a b
c d

Fig. 6.

 ERE the pattern follows fig. 3, a~n, to give the first turn of the clockwise spiral with four branches, fig. 6, b.

Two opposite branches may be connected by a zig zag stroke, fig. 6, c. These set off opposed locks. Last, put keys in the locks, fig. 6, d.

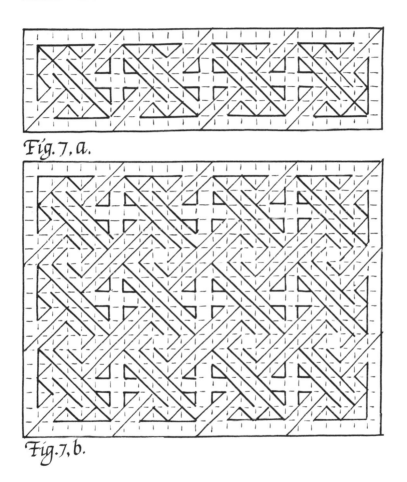

Fig. 7, a.

Fig. 7, b.

IGURES 1 to 6 in this intro-
ductory outline show how
the basic key pattern contains
in its structure the seeds of all
the mainstay variations used
by the ancient scribes. There are of
course other species sprung from
different seed structures, but
these more unusual key patterns
can wait for now.

Fig. 7, a, introduces another
diamond filler, in a repeat of four
basic units on a square grid seven
down and twenty-five across.

Fig. 7, b, is on a grid 25 x 19.

Leaving key patterns aside, for
now, let us take a look at spirals
with keys, let us play with spirals.

 PIRALS: THE SINGLE SPIRAL.

Figure 1.

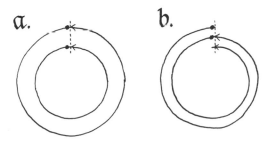

a. b.

Compare the two figures above. The single spiral on the right turns twice, so it has the same effect as two concentric circles, fig. 1, a; that is, the inside is surrounded by a path separating it from the outside.

Single Spiral: s-scroll.

Fig. 2

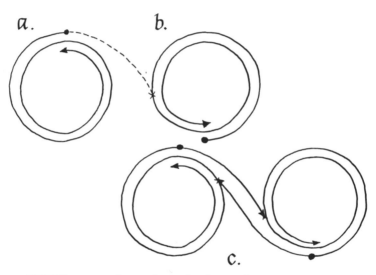

a. b.

c.

Two singles joined so the path
leads from one to the other.
Notice how the spiral at f.2,a, starts
at the top, and f.2,b, starts at the
bottom.

The path connecting the spirals is drawn with two lines. The first joins the outside of the path of the first spiral, f.2,a, to the inside of the second, f.2,b, as shown dotted here. The second line joins the bottom of b to the inside of the first spiral, f.2,c. The path now leads from the inside of one spiral to the empty centre of the second. This integrates the design so that it may not be entered from without, being completely self-contained. In traversing the spiralling path you begin at the centre and end at the centre. We cannot expand further on this design externally, but we may elaborate the middle spaces.

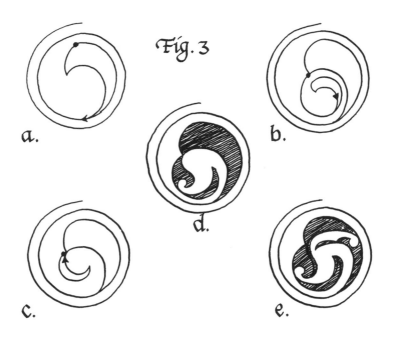

Fig. 3

a.

b.

d.

c.

e.

here you have five variations, all developed from the "comma" path ending, f. 3 a, from which are derived f.s 3, b, c.

Figures 3, d and e are types of "duck-head" terminal. Figure 3, e is a "triskel".

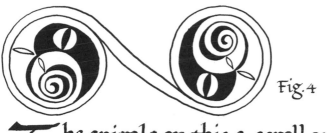

Fig. 4

The spirals on this s-scroll are identical, based on *fig. 3, b*. One is upside down in relation to the other. Any spiral in *fig. 3* may be treated as an s-scroll. A counter may be drawn to relieve the largest background space - such as the "eye" used here. This should not be overdone: one counter per largest background space is sufficient in most instances.

In *fig. 4* there is a second type of counter, to be used only where the path flares widest, called a "lens".

Fig. 5

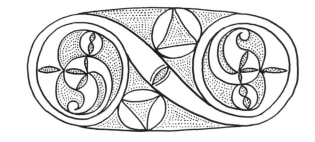

The spiral on the left is the same as at *fig. 3,d,* the "duck-head" terminal. Three lenses have been added in each duck-head, plus one at the widest point of the path. Inside the widest part of each spiral's background is a counter circle, containing two lenses. Between the two spirals the path diverges, at which point a bracketed lens, or "trumpet mouth", is used to counter the path's width.

The s-scroll may be enclosed with lines. The background is also countered.

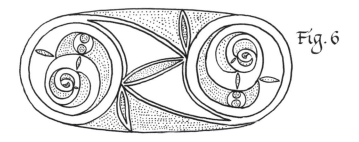

Fig. 6

In this figure, the path between the spirals has been made as wide as can be. With the path so wide as this, the centre lens may be outlined as shown, and the outline continued back along the path.

With so much path, the lenses either side of the cross over have been in-lined and filled-in, to counter as much as possible of the outer background.

Inside the spiral roundels the counter used - that looks like an apple-core-is called

[45]

SINGLE SPIRAL DUCK-HEAD TERMINAL from TORRS PONY CAP

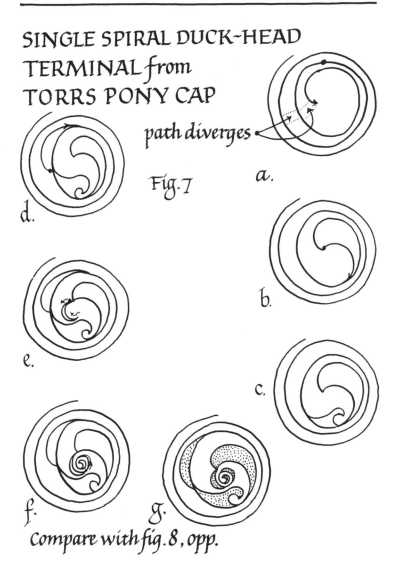

path diverges

Fig. 7

a.

b.

c.

d.

e.

f.

g.

Compare with fig. 8, opp.

a "labrys", but as the labrys has many other forms, I shall call this one "the apple-core".

One of the earliest forms of the duck-head appears in the N. British school of Celtic metal work that produced the Torrs Pony Cap, about 250 B.C. The basic design may be drawn in one continuous stroke as shown in fig. 7, a–d.

Fig. 8

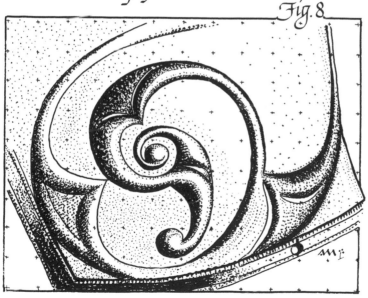

Fig. 8 shows a detail from the Torrs Pony Cap. The design is the prototype of spiral roundels that reach their fullest flowering 1000 years later in the Book of Kells. Modern Celtic artists wishing to develop the tradition further should first grasp the essentials of the art by a close study of the earliest forms such as underlie the later developments.

Fig. 9

Llyn Cerrig
Lunula
plaque:

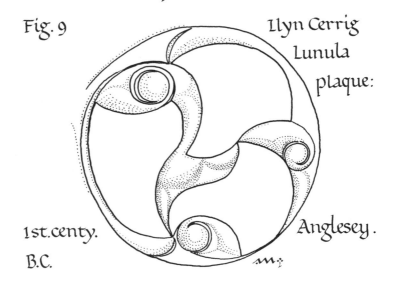

1st. centy.
B.C.

Anglesey.

Fig. 10

Fig. 10, for example, seems to be a complete departure from the tradition, but in fact, it is based on the Llyn Cerrig roundel, Fig.9. The pattern here is based on petal shapes, freely drawn and randomly grouped. The petal comes from the shape between the spirals in the basic s-scroll, Fig. 11.

Fig. 11
From circular box lid,
La Tène period, 1st. cent. B.C.,
Cornalaragh, Co. Monaghan.

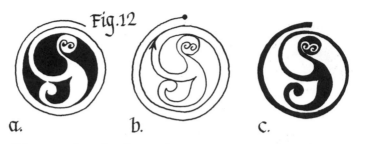

F.12, duck-head type terminal, Torrs Pony Cap. Background and foreground are interchangable, f.12,a,c. Single stroke construction also shown at f.12,b.

Fig.13.

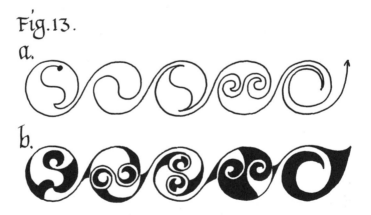

Fig.14

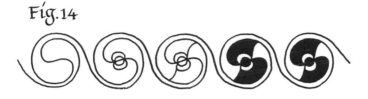

The single line construction appears in this design from Balmaclellan, Kircudbrightshire, c. 30 A.D., f. 13, 14. This is also a series of double spirals, ending in a single spiral, extreme right, f.13. See also the border below, which starts and ends in single spirals, f.15.

Fig.15

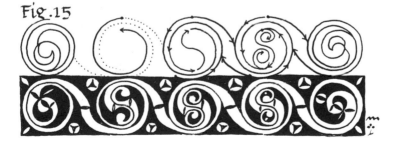

Double spirals in an s-scroll oval, or "cartouche".

Fig 16.

a.

b.

c.

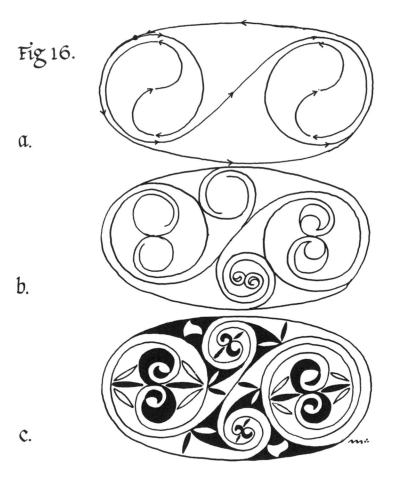

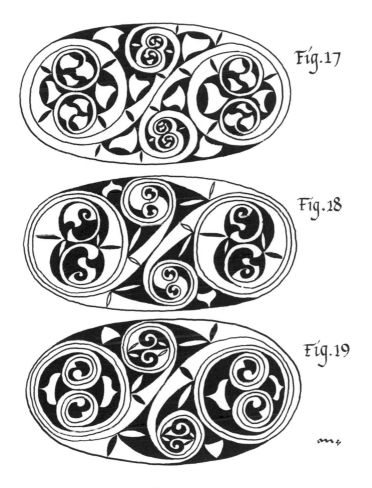

Fig.17

Fig.18

Fig.19

Compare f.17 with f.10; and com-
pare f.s. 18, 19 with f.13.

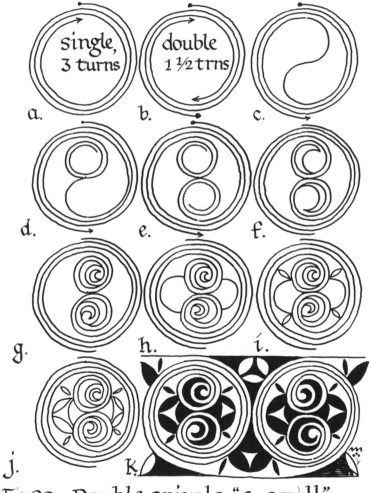

single, 3 turns

double 1½ trns

a. b. c.

d. e. f.

g. h. i.

j. k.

Fig. 20 Double spirals, "c-scroll".

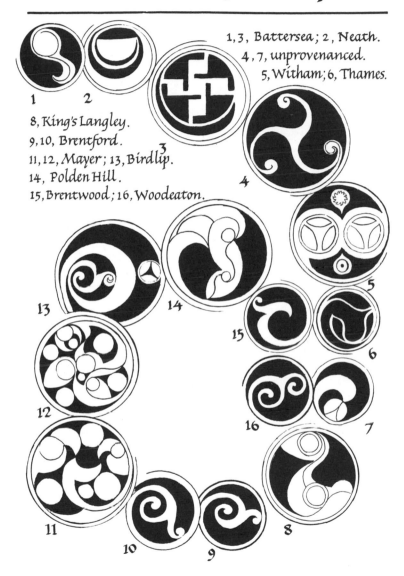

1,3, Battersea; 2, Neath.
4,7, unprovenanced.
5, Witham; 6, Thames.

8, King's Langley.
9,10, Brentford.
11,12, Mayer; 13, Birdlip.
14, Polden Hill.
15, Brentwood; 16, Woodeaton.

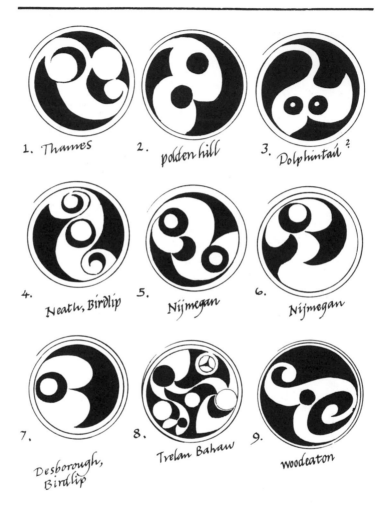

1. Thames 2. polden hill 3. Dolphintail²

4. Neath, Birdlip 5. Nijmegan 6. Nijmegan

7. Desborough, Birdlip 8. Trelan Bahaw 9. woodeaton

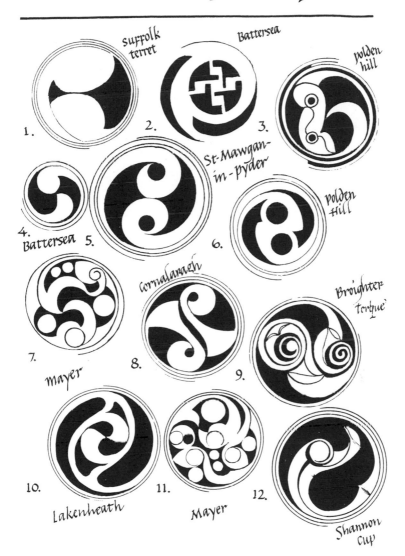

Suffolk terret

Battersea

polden hill

1.

2.

3.

St-Mawgan-in-Pyder

polden Hill

4.
Battersea 5.

6.

Cornalaragh

Broighter Torque

7.

8.

9.

mayer

10.

11.

12.

Lakenheath

Mayer

Shannon Cup

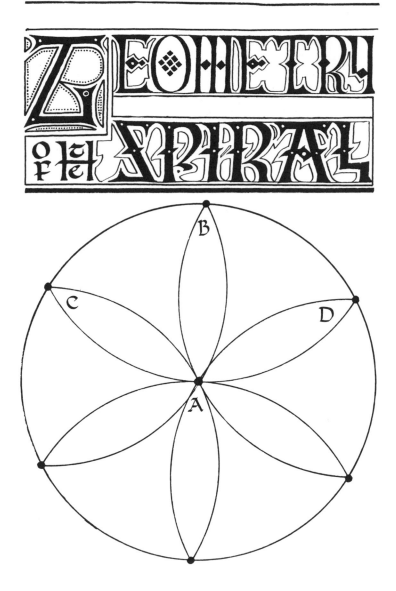

D raw circle, centre A, page 58.
With same radius, and centre
B, draw arc, C D. Keeping same radius
step off the six points, and join in
the form of a star as here:

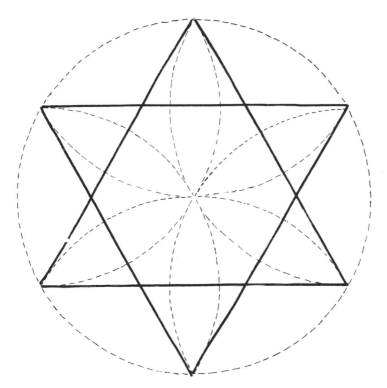

H ere the star is used to con-struct a triangular grid. This grid is used to construct four circles, opposite.

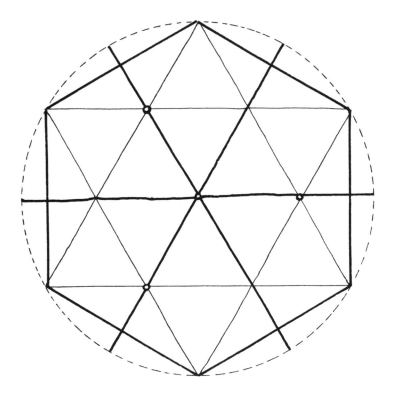

The distance between the inter-section of the star triangles & the outer hexagon, AB, provides us with the radius for close-packed circles.

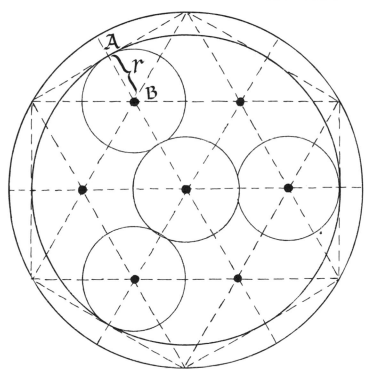

S imilarly, seven circles may be packed together.

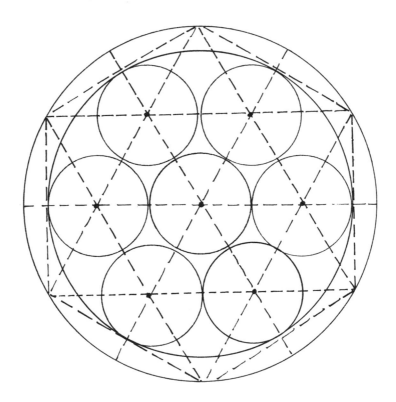

E ach circle contains a star. So the whole is reflected in the parts. Triple spirals may be placed in the shaded stars, as will be shown.

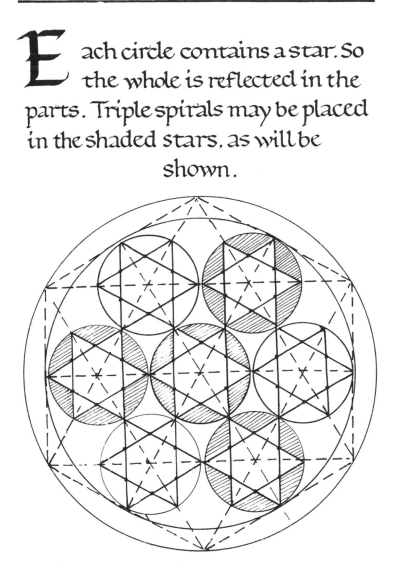

W ith centres A,B,C
draw arcs DE,FG,HI.
These arcs will connect the triple
spirals.

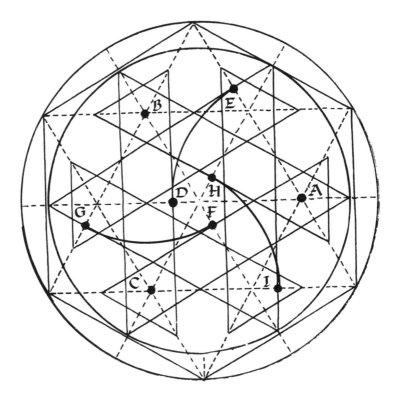

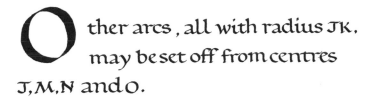ther arcs, all with radius JK,
may be set off from centres
J, M, N and O.

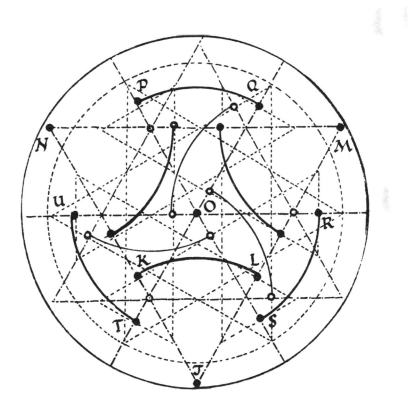

Here the ends of the arcs have been wound into spirals, double and triple. The result is a regular design of continuous line spirals.

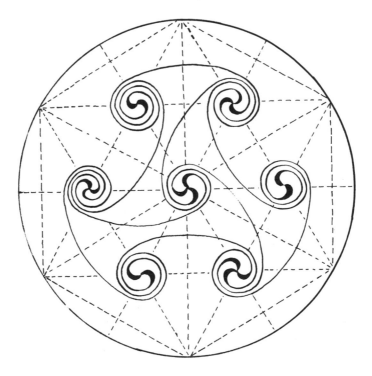

B y the addition of three sets of three arcs, the line spirals are converted into interlocking c-scroll paths. The arcs supply bulges in the passages from spiral to spiral.

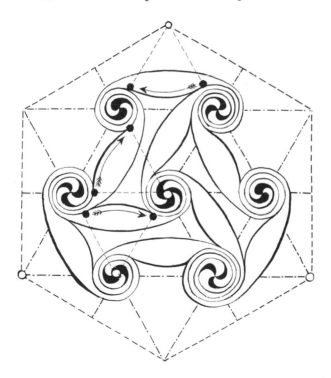

The roundel on the previous page has three double spirals. The addition of one more coil to each of these makes an overall triple spiral, composed of triples, linked together in opposed pairs.

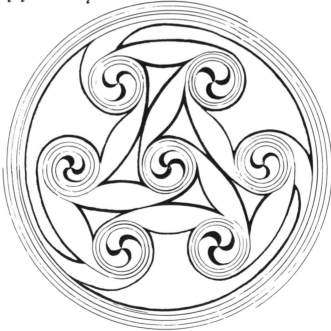

As seen above, page 63, the whole is reflected in the parts in the geometry of circle, hexagon & star, the same geometry as generates the triple spiral roundel, opposite and here beneath:

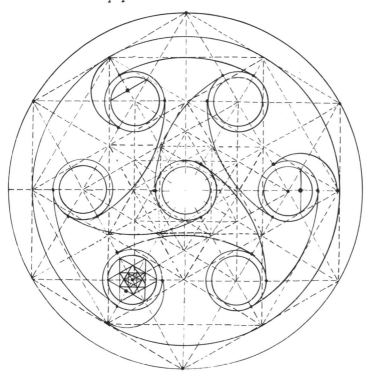

Chapter IV

WITH this in view it follows that the whole triple spiral design may be reflected in each of the triples contained within it, thus:

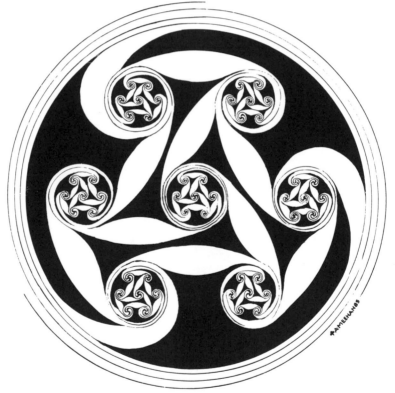

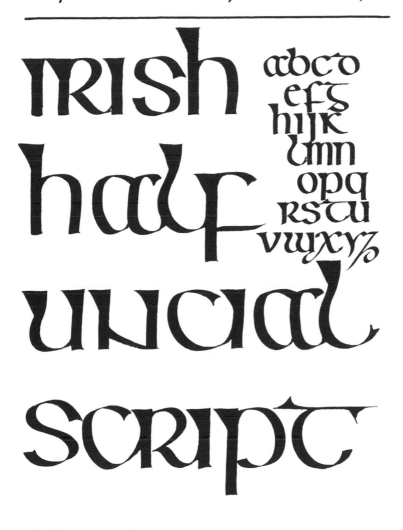

irish abcd
efg
hijk
lmn
half opq
rstu
vwyxyz

uncial

script

Alphabet written with Speedball nib, C-1.

5 nibwidths

"fishtail"

Serifs:

Flat Lift off

Stroke trail

ascender, 2½ nib widths.
"x" height, five n.w's.

Flag serifs, on tops of
straight, vertical strokes only,
except for 'b' and 'l', which
begin straight, then
curve.
Letters b, upright d,
f, h, i, j, k, l, m, n, p, q, r,
u, (v), w, (y), all have
flag serifs. While
Fishtails are optional, 20°
flag serifs are not.

For the most part, except for serif and foot pen–
twists, pen angle should approach a 20° constant.

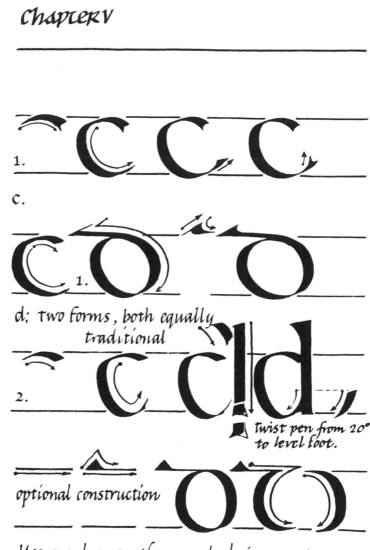

1.

c.

1.

d; two forms, both equally traditional

2.

twist pen from 20°
to level foot.

optional construction

Use one d or another, not both in same text.

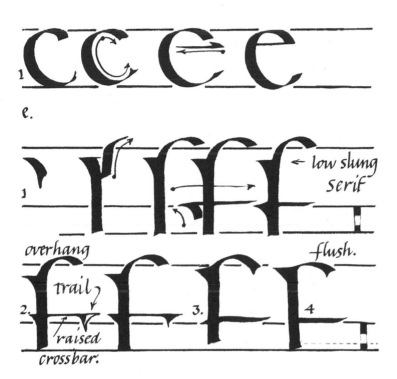

e.

← low slung serif

overhang

trail⟩

raised

crossbar.

flush.

f: several versions, 4 is the most compact.

eg, et – this type of tall letter e is used before t and g.

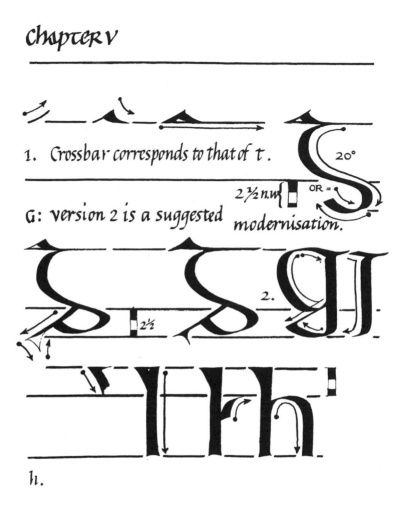

1. Crossbar corresponds to that of t.

G: version 2 is a suggested modernisation.

2½ n.w OR =

20°

2½

2.

h.

The tail serif on the celtic g may be trailed with the left hand corner of the nib. The modernised form is based on q, below, and may be used with q, 1.

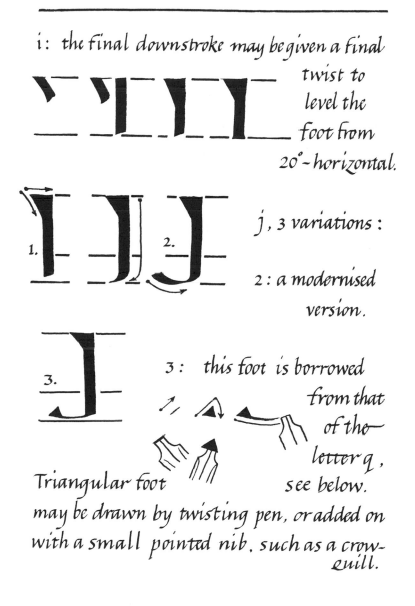

i: the final downstroke may be given a final twist to level the foot from 20° - horizontal.

j, 3 variations:

2: a modernised version.

1.

2.

3.

3: this foot is borrowed from that of the letter q, see below.

Triangular foot may be drawn by twisting pen, or added on with a small pointed nib. such as a crow-quill.

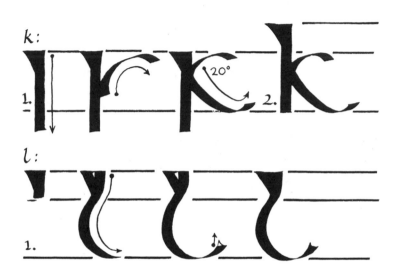

There is no letter k in the original Celtic mss., so one of the challenges is to supply missing letters, j, k, v, w, as well as to modernise the archaic ones, particularly g, q, t, and y. Here the first k is very compatible with the old forms, while k2 is slightly modern looking.

m:

1.

2.

m; two variants, the first is the regular one,
the second only for use as the first letter of a
word. The point to remember about the letter
m is that its arches are much narrow than
the arch of n or h.

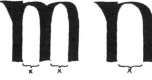

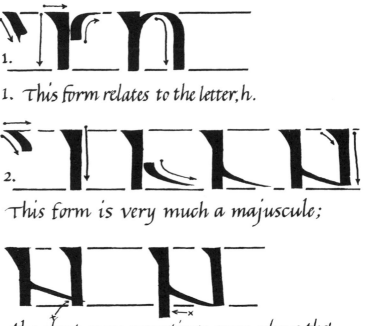

1. This form relates to the letter, h.

This form is very much a majuscule;

the slant may sometimes come above the
right foot; the left foot may descend a little.

These two n's, however, should not be used in
the same text. Use one or the other.

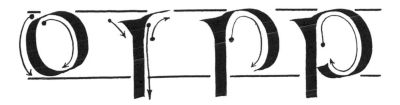

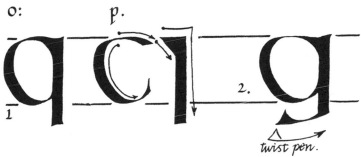

o:

p.

2.

△
twist pen.

3

e, 3 variations: the first two are traditional. the third is a modern version, with a reversal of the foot; this last may be used with g, 2, above, as may q,1.

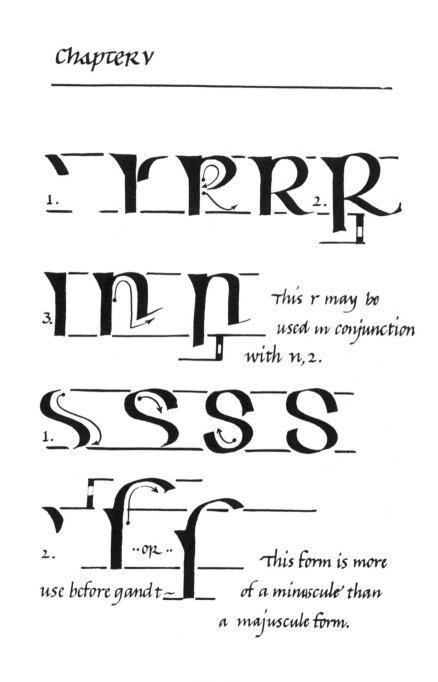

1. **2.**

3. This r may be
used in conjunction
with n, 2.

1.

2. ..or.. This form is more
use before g and t ~ of a minuscule than
a majuscule form.

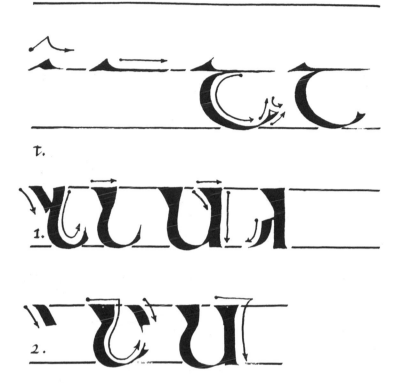

t.

1.

2.

The difference between u, 1 and 2 is that the first is pulled straight from the serif into the curve; the second bends to the left, rather than being pulled down straight.

[83]

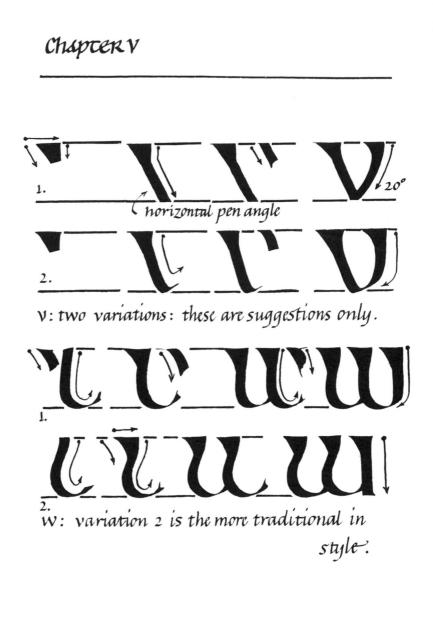

1.

horizontal pen angle

20°

2.

v: two variations: these are suggestions only.

1.

2.

w: variation 2 is the more traditional in style.

x , 5 variations:

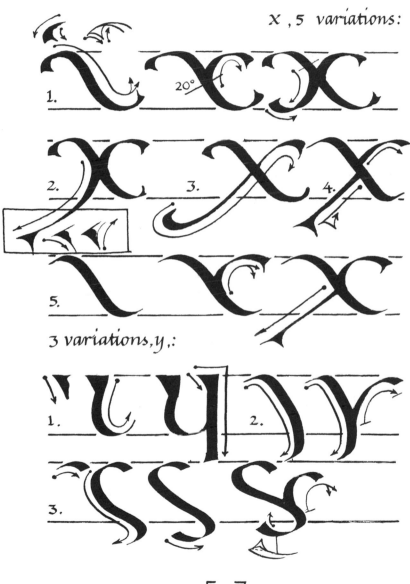

1. 20°

2. 3. 4.

5.

3 variations, y ,:

1. 2.

3.

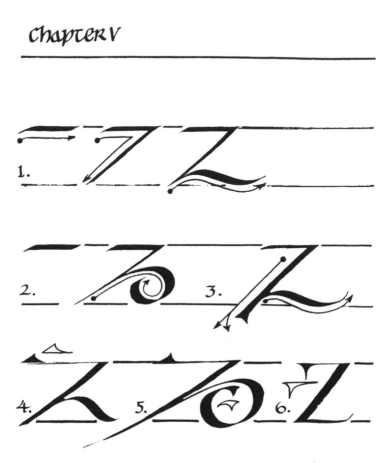

z : like many of the letters in this alphabet,
z allows for a number of mutations, where-
by the pen may be given free play. Here, 3,4,
6 are variants of 1, while 5 is a variant of 2.

HOW TO LAY OUT A MANUSCRIPT PAGE ✤

ONCE YOU

are familiar with the letters of any particular script it is best to select a text and produce a single-page manuscript, or a number of such pages. A text may be written over many times, and may be improved a little each time; you can develop a sense of design by doing this, and produce work that truly pleases you, that you may include in your portfolio, or present, suitably matted and mounted of course, to a friend.

[87]

FIRST you need a lot of paper. It need not be very special but it is worth getting a batch of good, non-acid, not too thin, smooth, white paper. 2-ply "Bristol board" does quite well. Stock up with 50 or 100 sheets from an art supplies outlet. A good size is 36"x 28". Store paper flat, wrapped up safe from damp, dust, pawmarks, and such. A closet may be adapted to paper storage by putting in shelves.

 HEN you buy a stock of paper in a whole or broken packet, keep it in its wrapper until ready to use. Remove as many sheets as you need, close up the remainder and return to storage. Keep the sheets in the same order as they came from the package, same face up, same corner alignment. Pencil lightly a mark in the upper left hand corner, to help keep the sheets in order. One side of the paper, for instance, is sometimes better than the other to write on, and you will want to find out which before ruling up your single pages, so as to stack the pages with the better side up.

MEASURING THE PAPER FOR CUTTING

TAKE ONE SHEET & MEASURE IT
18" along one side, 14" the
other. If your sheet is 36"x 28"to
begin with, it will quarter
economically to a standard
18"x 14" page ; if not, trim it down.

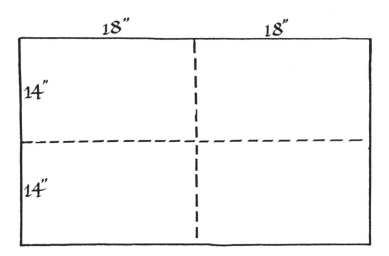

MARKING THE CUTTING MAT.

T RIMMING A LOT OF PAGES
may be done more easily
on a cutting mat, a sheet of
dense card or illustration board
at least ⅛" thick, 4' x 3'. On this,
pencil the 36" x 28" area, divide
each side and quarter the area.
Having checked the lines and an-
gles, ink in the marks for the
corners and the cuts to be made.

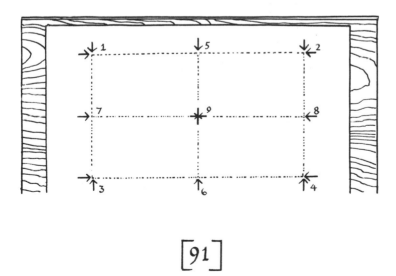

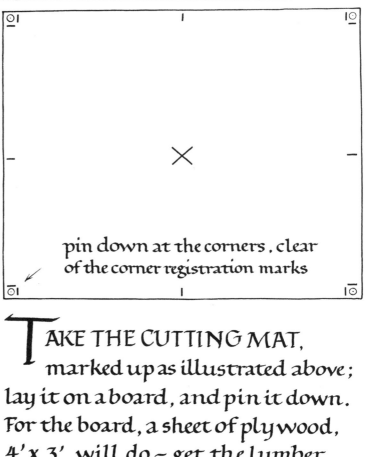

pin down at the corners, clear
of the corner registration marks

Take the cutting mat,
marked up as illustrated above;
lay it on a board, and pin it down.
For the board, a sheet of plywood,
4' x 3', will do – get the lumber
yard to cut down an 8' x 4' sheet to
a couple of boards; both will prove
handy to have about the studio.

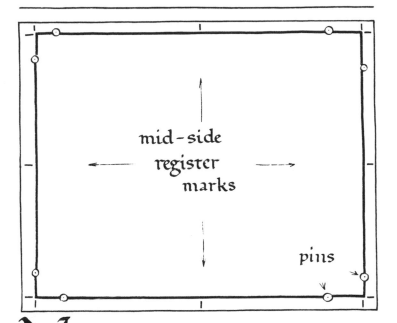

mid-side
register
marks

pins

N OW TAKE A NUMBER OF
sheets; squared up, stacked
and lined up on the cutting mat
with the corner registration marks.
Pin down the stack with old-fash-
ioned, large-headed drawing pins;
pin clear of the register marking
the mid-point of each side.

[93]

When you pin the stack of pages, do not pierce the paper with the shaft of the pin. The head of the pin only should hold the paper. The bigger the pin-head, the better.

pin

The sort of blade you snap off is very handy.

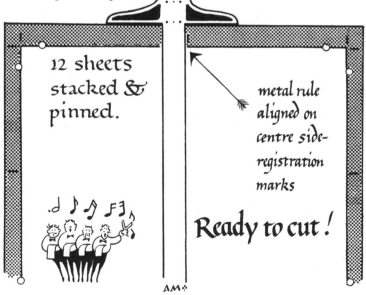

12 sheets stacked & pinned.

metal rule aligned on centre side-registration marks

Ready to cut!

AM

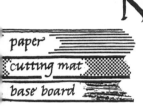

paper
cutting mat
base board

Never use a wood or plastic edged ruler when cutting; a metal edged or all-metal ruler is a must for all cutting jobs.

When cutting, press down on the ruler with one hand, but do not press on the knife any more than is needed to cut through a single sheet at a time, for the most accurate result. Remove the cut sheets one by one.

Make the first cut from top to bottom. Then cut from side to side, according to the registration marks. Snap off the blade, half-way through.

OW YOU HAVE CUT A
dozen sheets, 36"x 28", into
four dozen pages, 14"x 18", or
an ample supply of standard-size
stock of paper suitable for single-
page manuscript, enough to last a
year.

You also have your studio equip-
ped to handle most cutting jobs.
The board and mat set-up will be re-
used as is. Store it flat against the
wall until it is needed again.

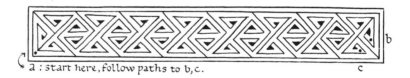

a : start here, follow paths to b,c.

 EXT the page must be ruled for writing, but ruling can become tiresome and off~putting, whereas a number of pages may be ruled all at the same time by means of a simple template.

HOW TO MAKE A TEMPLATE FOR RULING

 ULE one sheet first, in pencil, according to the plan illustrated on the next page. This is the master lay out for the template, and therefore should be made as carefully as can be. Check the corners and the intersections with the T-square and set square to be sure the right angles are true.

[97]

THE RULES' spacing given here is standardised to the proportions of a nib width of ⅟16".

We will use a Celtic script, of which the letter 'o' is five nib widths high.

The rules are three 'o's' apart, or ¹⁵⁄16".

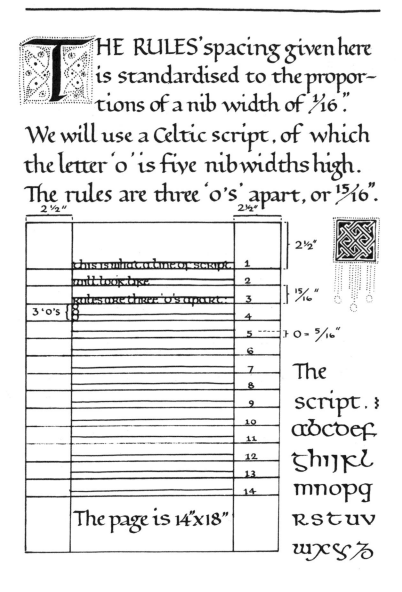

2½"

2½"

2½"

¹⁵⁄16"

1 · o = ⁵⁄16"

this is what a line of script
will look like
rules are three 'o's apart.

3 'o's {

1
2
3
4
5
6
7
8
9
10
11
12
13
14

The page is 14"x18"

The
script. }
abcdef,
ghijkl
mnopq
rstuv
wxyz

WHEN you have this page all ruled up, you can use it to rule up a number of other pages, as a template. To make the template, with a pin, prick holes through the page where the rules for the lines cross the margins. With a pencil you can trans fer the points on to a second sheet placed directly beneath the template. Removing the template, the second sheet may be ruled up according to the transferred guide points. Like-wise, the template may be re-used to rule any number of single-page manuscript pages.

Or, with a fine, strong pin, you may prick through several sheets at once.

[99]

HOW TO
DECORATE
LETTERS

ı, n, o, ë, and l

FIRST OF All WE NEED some letters to decorate. They may be drawn, as on the following pages. Here I have simplified the old Irish letters, called Majuscules, and presented them in a proportion which is based on a 5²grid.

ll the letter forms on these
pages are intended as models
for drawing the outlines
of outsize letters to be
illuminated with Celtic ornament.

I have given the grid as based on
a square divided into five on each
side, or 5x5, because I have found
this to have had special significance
to early illuminators, such as those
of the Lindisfarne Gospels. Also,
this gives a good proportion be-
tween the width of the stroke and
height, as of the letter 'I', for
instance: $\frac{1}{5}$. With the addition
of the outline, this proportion ap-
proximates the Lindisfarne ideal
nibwidth: i-height, $1:4\frac{1}{2}$.

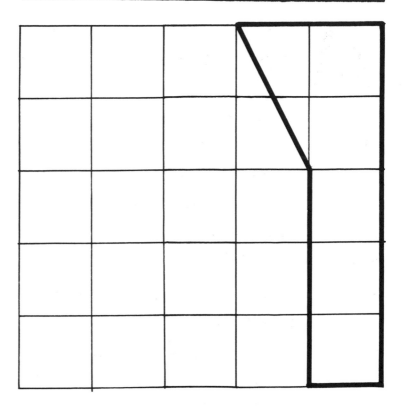

The side of the square is the height of the letter 'I', as here, or width of an 'O', page 109, below. If it were pen-written, it would be 5 nib widths high.

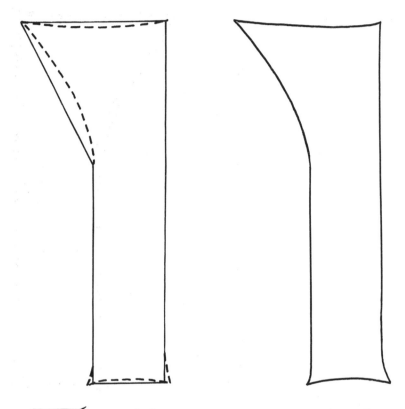

The grid gives us a standard proportion for majuscules, as well as the ideal flag serif. The angles may curve a little, as here.

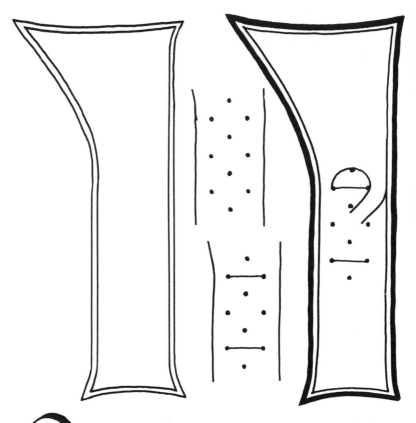

Outline the letter; thicken up the outline; add another outline. Colour the interior lightly and brightly – or put in a knot.

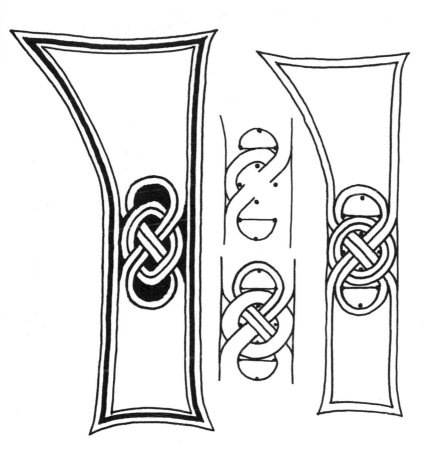

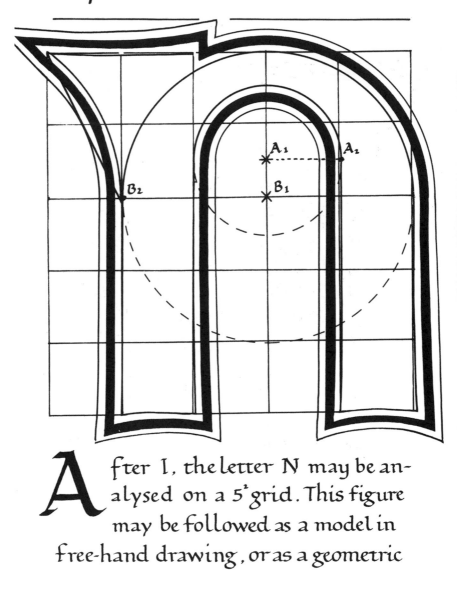

After I, the letter N may be an-
alysed on a 5'grid. This figure
may be followed as a model in
free-hand drawing, or as a geometric

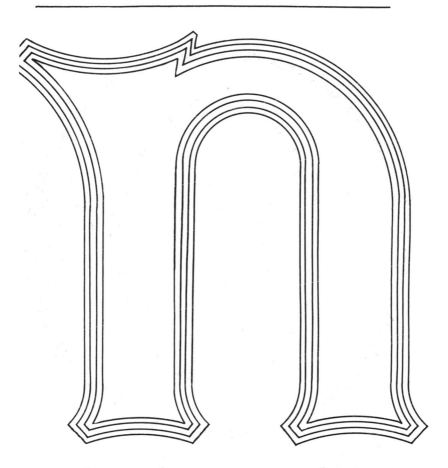

exercise. With compasses and ruler
the entire letter may be produced.
The centre band may be coloured.

[107]

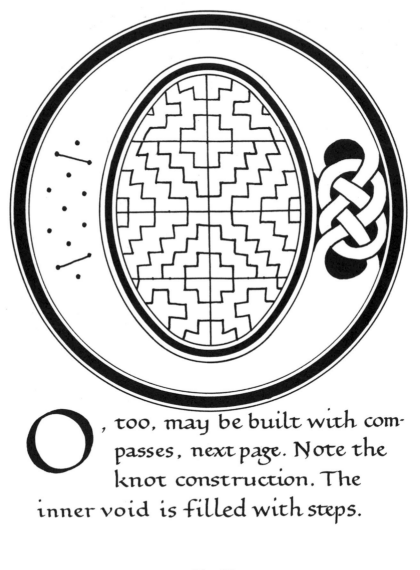

O, too, may be built with com-
passes, next page. Note the
knot construction. The
inner void is filled with steps.

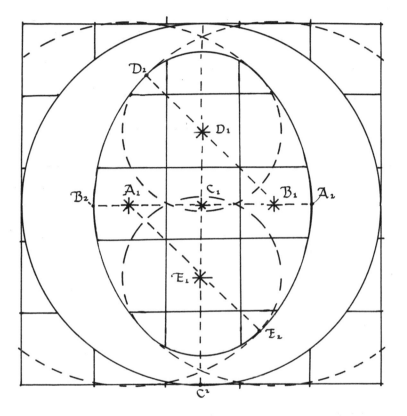

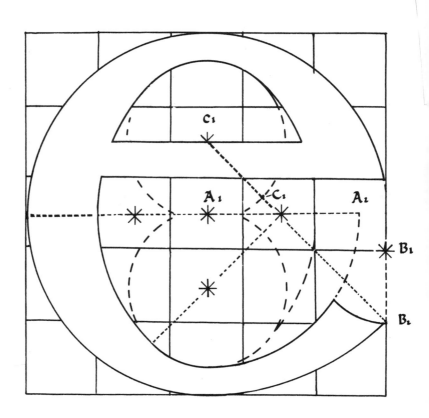

E follows the geometry of O, but for the curve of the tail; A_1A_2; C_1B_2. If not following the geometry, use squared paper to plot the

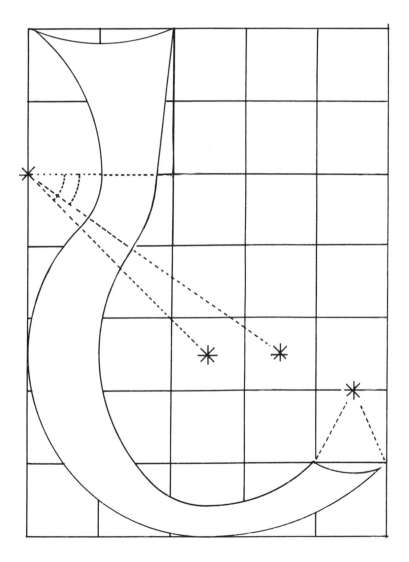

letters, trace and transfer.

The form of the majuscule L, over leaf follows from E, and introduces our grid for ascenders, b d h l, and descenders, fɟjκpqxyʒ : 5 x 7. The descender of f, κ, x, ʒ is characteristic of the archaic script. Now f, k, are ascenders, while x, z have joined the mid-height tribe based on i : m, n, R, u, w; and on o : c, e, s, c, x.

It may also be remarked that here the letters are not capitals, to which we are accustomed; but although the old a, b, c, ɒ, e, f, ʒ, h, i, κ look like small letters, or minuscules they originally had the status and dignity of formal capitals.

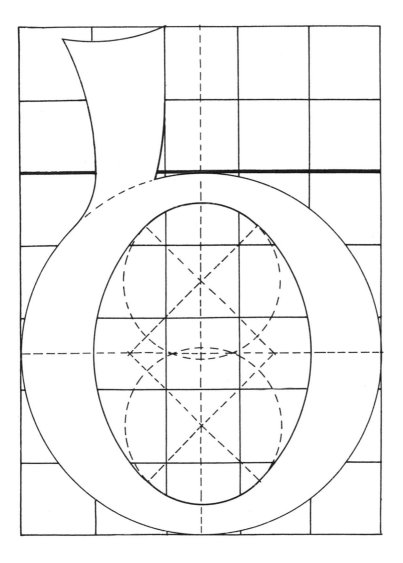

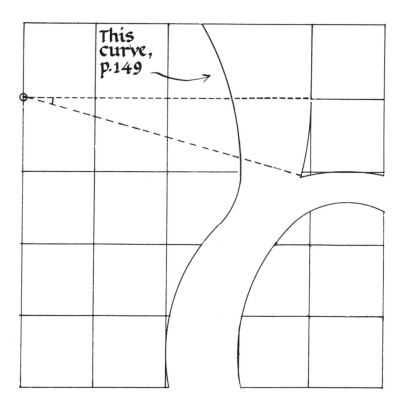

This curve, p.149

COMPARE the top of the
B with that of L, p. 111.
This narrower, blunter
serif is preferable.

WHILE the body of B follows from O, the D stems from C. C has the same tail as E. H is likewise close to N, p. 106 & 118 .

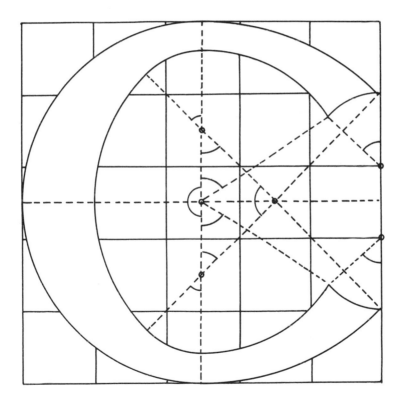

here are two curves to the serif of D.
This concludes the ascenders.
Next,119-127,the descenders: F,G,J,K, P,Q,X,Y,Z.

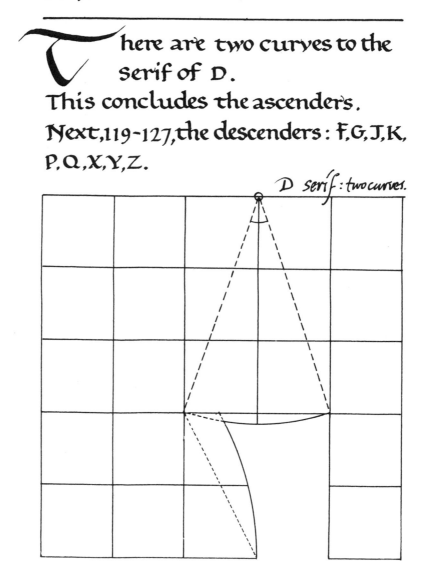

D serif : two curves.

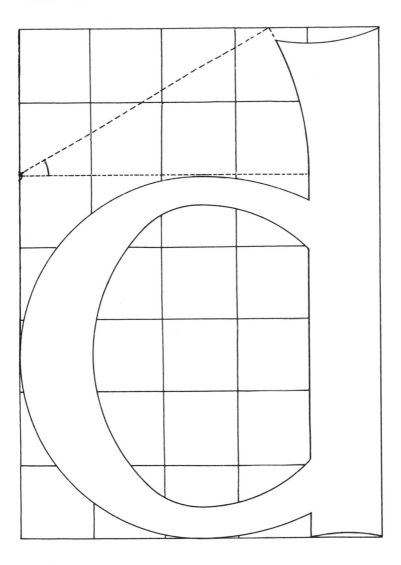

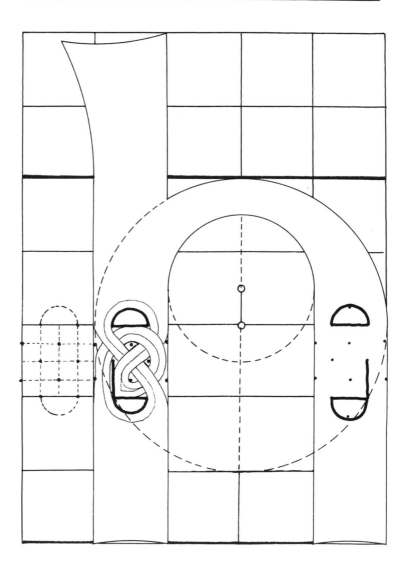

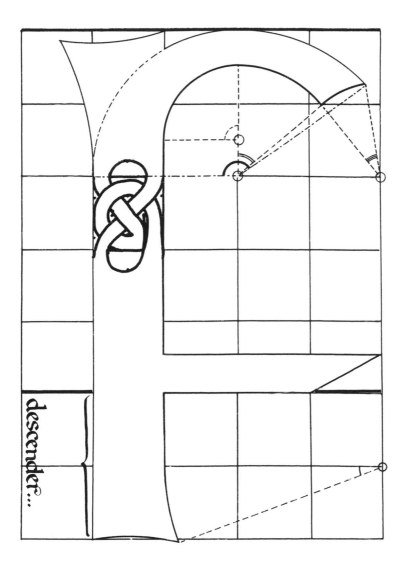

descender...

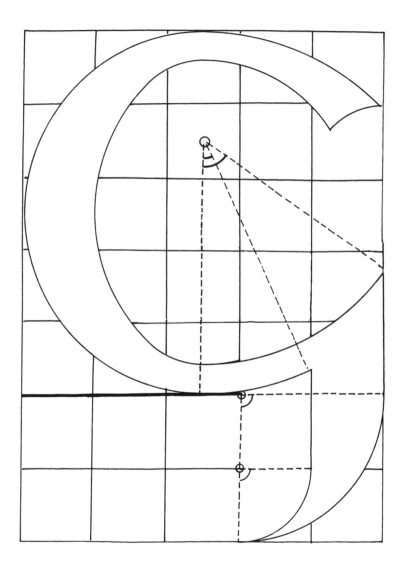

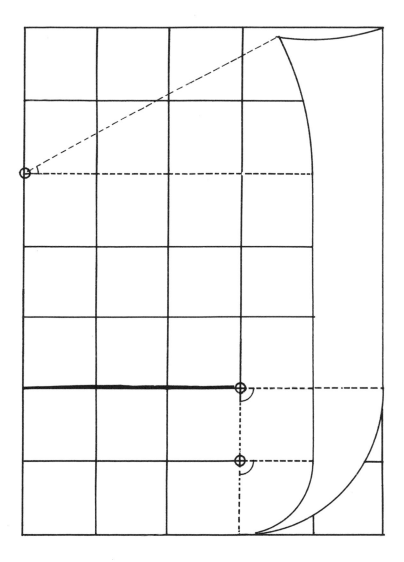

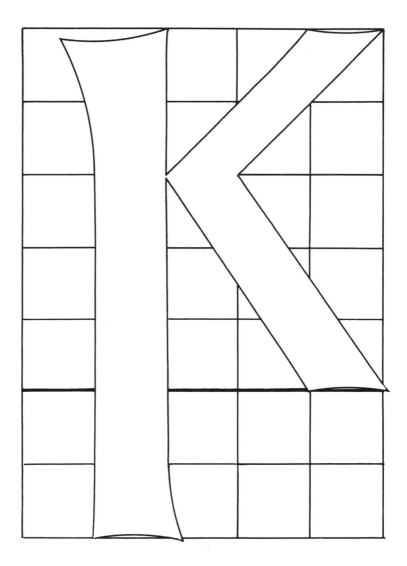

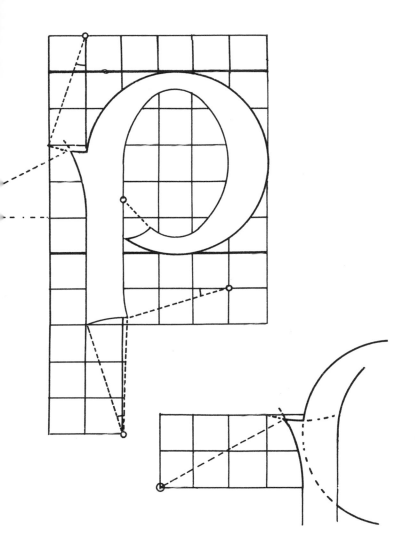

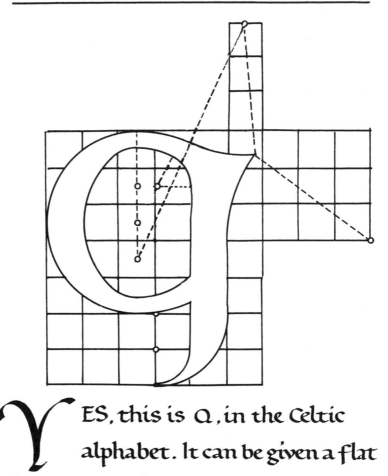

Y ES, this is Q, in the Celtic alphabet. It can be given a flat foot to match P, too.

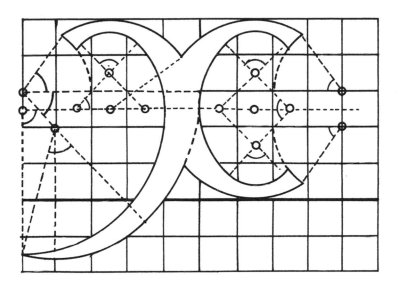

The X is a descender, as we see here. Each half is a cut-off O, with the tail added, sweeping away below leftwards. Or, equally, it could be done symmetrically; the left reflecting the right.

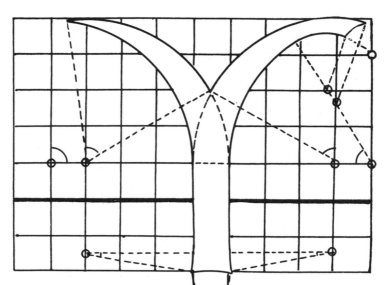

HERE is a simplified form of Y, with a straight descen-der. This foot is quite symmetrical. A curve, as in Q, would do as well. The sharp prong could be re-

peated on the right .. Y, like G, is
pretty versa-
tile. So is the
celtic ZED :
those dots
are centres
for drawing
the success -
ion of arcs

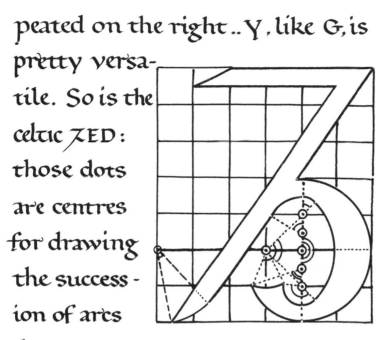

that may be compass drawn to pro-
duce the spiral tail.

WHICH brings up the point,
WHY bother with the geometry
at all ?

As forms, letters are pen-made
shapes. When a letter is to be
decorated, however, it may be
drawn freely or with compasses.
Many including myself find it eas-
ier to draw a straight line with a ruler,
a curve with compasses. So here is an
alphabet of letters produced by com-
passes and ruler entirely. By this
means, sharp, controlled, well-
proportioned and lively shapes
may be obtained. Few can do this
free hand on a large scale, so here
the letters are given along with
their geometry. Besides, it really
is fun to do, and compass work
is an essential element of early
Celtic art. This is good practice.

As well as ascenders and des-
cenders there are the let-
ters with neither, namely:

aceim

orstu

vwnd*

* this letter has two forms, an as-
cender, d, and the flattened
form, d, as here.

[129]

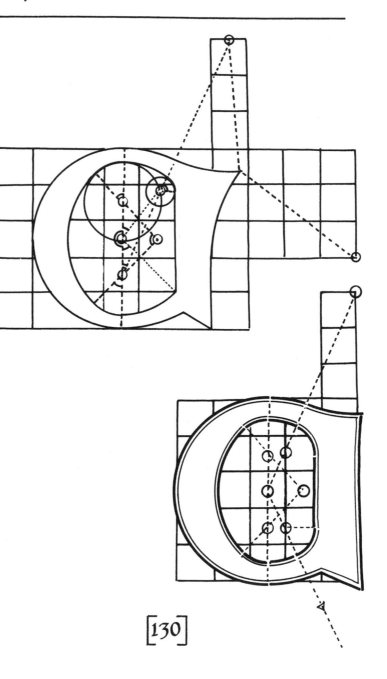

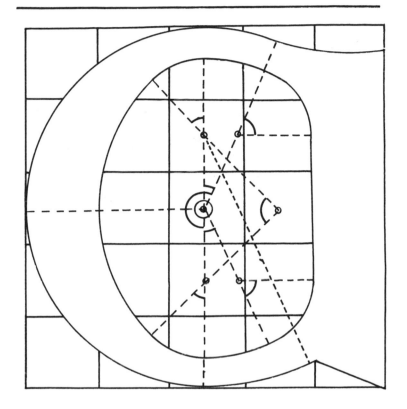

This page, as below, opposite, a simple form of the Celtic letter, α. Opposite, above, a variation of the serif, like that of α, on page 124. 🔲

INSTEAD of decorating the letter with a plain knot, it can be done with animal-shaped, zoomorphic pattern based on a knot, as here. Each snake has two long ears, laced into the weaving body-ribbons.

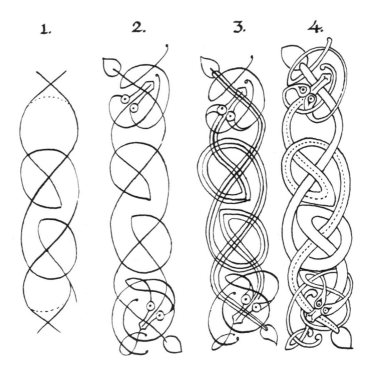

1. 2. 3. 4.

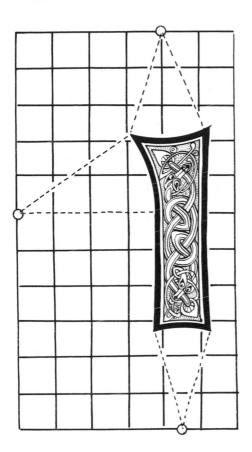

construction
of the knot
used here in
the snakes.

R: • The stem of this letter is
 • made the same way as 'l'.
The curve uses five centres, 3 for the
outside, top left, opposite page.
HERE'S HOW: draw the arc 1, with
the compasses fixed at centre 1.
With the same centre, repeat the
curve of the outline; step the fixed
point to centre 2 and draw arc 2,
inline and outline; continue arc
3 with centre 3.

FOR the inside curve, keep the
centre at 3, and draw inside curve
3, see figure lower right. Continue
the inline (thin) and outline (thick)
through curve and centre 4: ditto
from centre 5.

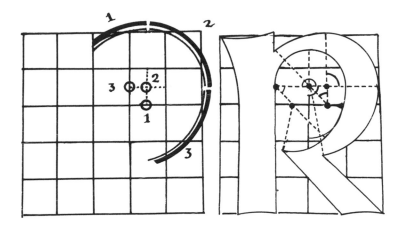

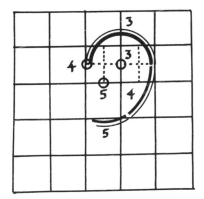

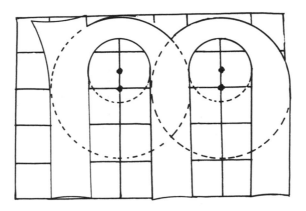

m: the steps for drawing
'm' are as follows:
lightly pencil a grid, 8 x 5.
Draw the stem, as for 'l'.
Pencil the circles, straight rule
the legs.
Extend the grid to draw the
hollows on the head & feet serifs,

as shown on page 133.
In drawing the letter, start at a
point, say upper left, then draw
each curved line or straight line
section continuously, each new
line starting precisely on and
springing from the end of the
last one; progress around the out-

[137]

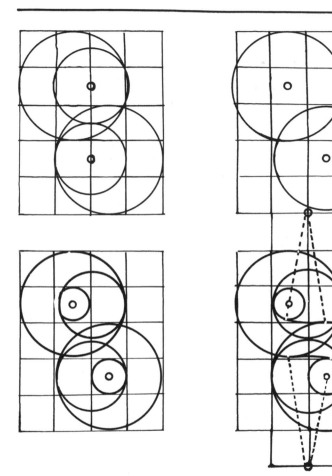

line, doing thin and thick lines together. Then repeat, in ink.

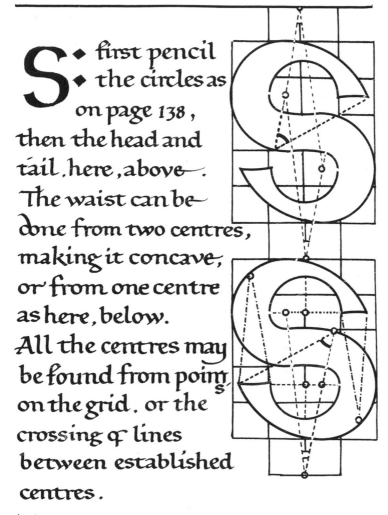

S: • first pencil
 • the circles as
 on page 138,
then the head and
tail, here, above.
The waist can be
done from two centres,
making it concave,
or from one centre
as here, below.
All the centres may
be found from points
on the grid, or the
crossing of lines
between established
centres.

 the body
of 'T' is like 'C'
on page 115
above.

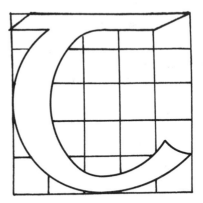

 opposite : extend the
square grid to make
the head and foot serifs on let-
ters such as 'U'. If you are inking
up the letter close to the edge of
the page and find you have not
enough room, you can extend
the page by slipping another ·
sheet alongside and partly un-
der the first, and taping it.

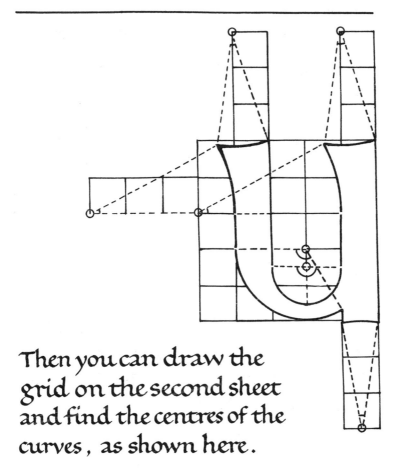

Then you can draw the
grid on the second sheet
and find the centres of the
curves, as shown here.

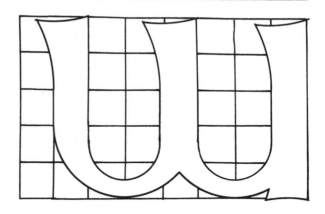

W :

here the letter is made up
of 'U', as on the previous page.
Another form is the 'Double-Vee',
as opposite, above.

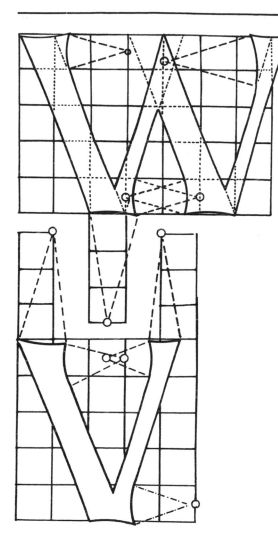

Conclusion

The letters here may be decorated with step patterns or key patterns. Use the illuminated letters you make as initials, personalised monograms, greeting cards, gift labels, fabric paintings etc. The patterns may be used in themselves wherever ornamentation is called for in art or in decor, in textiles, tiles, metalwork, woodwork, murals; the applications are as many as may be imagined. With pen and paper you can easily master the patterns in this book. Then look around and apply them in your own life, however you may feel inspired. The aim of this book, and that of the entire series of "Celtic Design", will thereby be fulfilled: the revival of Celtic art. ✝

HERE is how you can divide the side of a square into five equal parts; the same means may be used to divide any straight line into any number of parts:

* Rule a line AB at not too steep an angle to corner of square, at B; the line is longer than the side of the square.

* Set dividers to what you guess to be about 1/5 of the side of the square, and step off this measure, 1~5.

* Put SET SQUARE so it passes through corner of square & point 5, place ruler against setsquare; HOLD RULER STILL, and slide setsquare along to point 4.

angle should be not too steep

SET SQUARE

RULER

* Draw line through 4, to cut base of square. Slide along to 3, 2, 1, & repeat cut. Base is now in 5 parts.

[145]

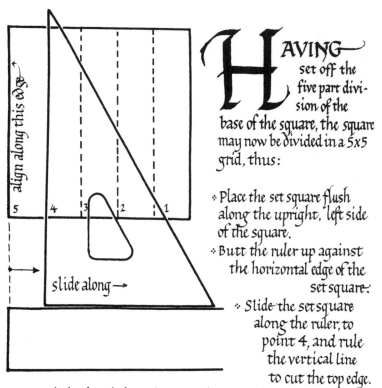

align along this edge →

5 4 3 2 1

slide along →

H
AVING
set off the
five part divi-
sion of the
base of the square, the square
may now be divided in a 5x5
grid, thus:

· Place the set square flush
along the upright, left side
of the square.
· Butt the ruler up against
the horizontal edge of the
set square.
· Slide the set square
along the ruler, to
point 4, and rule
the vertical line
to cut the top edge.

· Now slide along the ruler to point 3, and rule across the
square to cut the upper edge.
· Carry on until the square is divided by lines cutting
through points 2 and 1.
· N.B. throughout, keep ruler steady. If it moves, move the
set square back to the edge and butt the ruler back into line.

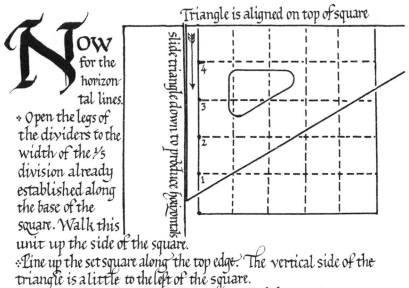

Now for the horizontal lines.

Triangle is aligned on top of square

slide triangle down to produce horizontals

❖ Open the legs of the dividers to the width of the ⅕ division already established along the base of the square. Walk this unit up the side of the square.

❖ Line up the set square along the top edge. The vertical side of the triangle is a little to the left of the square.

❖ Butt the ruler against the upright side of the square.

❖ Using the ruler as a guide track, slide the triangle down to point 4, and draw the horizontal across.

❖ Likewise, produce remaining latitudinal parallel lines at points 3, 2, 1, to complete the 5x5 grid.

The grid can be extended beyond the square with the ruler, by projecting the horizontal and vertical lines. To make a grid 8 across and 5 down, first extend the square by producing all the horizontal lines. Step off the ⅕ of the square to three spaces as before; place ruler horizontally below the figure as on previous page, as a rail along which to slide the set square and thus complete the grid.

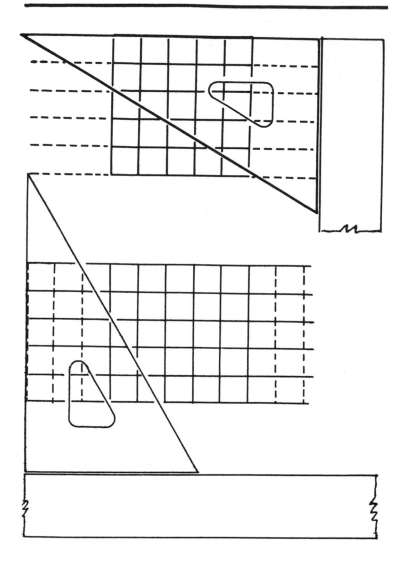

HE set square and ru-
ler may be used to
extend a grid on either
side of the square, not only to
lay out a wide letter, but also to
find centres for serifs and such
which may lie off the area to
one side or the other. With a pair
of dividers, a set square and a stra-
ight edge, a grid may be extended
indefinitely, horizontally or verti-
cally. As Celtic patterns are based
normally on grids, it is necessary
to know how to construct such a
grid. The alphabet here presented
provides an opportunity to deve-
lop skill with these tools of design.

[149]

Appendix

USE the triangle to lay out a page of text like this : with the top of the page as a horizontal, and the triangle flush with this, set the corner of the set square to the left of the left-hand margin and set the ruler against the vertical side of the triangle. Hold the ruler firmly between thumb and middle finger, slide the triangle down to the point on the margin line for the top of the text, and hold it there with the index finger of the left hand; the finger on the triangle need not press as heavily as the two on the ruler. With the right hand, draw the horizontal rule, while the left

holds the ruler & triangle steady.
Should the ruler slip, begin again. It
may slip if you relax your pressure
on the ruler, forgetfully. This initial
tendency is remedied by practice. If
the ruler swivels, however, it may
be bowed, and should therefore be
discarded and replaced. If you use
wood rulers, get two at a time, to
cover the possibility of warpage in
one of them.

Having ruled the horizontal line
marking the head of the text, next do
the vertical margin lines: move the
triangle to the corner of the text area,
upper left, flush with the horizontal.

Appendix

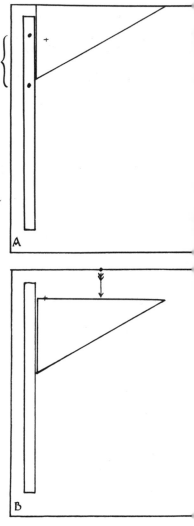

A: to establish the upper edge of the text block, place triangle along top of page; butt the ruler against the vertical edge of the triangle; hold the ruler in place with thumb and middle finger.

B : slide the triangle along the ruler to where you have decided the top of the text should be. Do this with one hand, keeping a firm pressure on the ruler all the while with thumb and finger. When the triangle is in position, hold it with the index finger of the hand holding the ruler. Thus one hand holds both ruler and set square, which leaves the other free to pencil the horizontal line atop the text block.

C : the horizontal line now becomes the guide for the left hand margin: slide the triangle over so that its corner coincides with that of the text block; butt the ruler against the set square; hold the ruler, take away the triangle, and rule the vertical.

D : likewise, the other side.

E : step the line spacing off on the left with the dividers.

F : mark the lower case "x-height" above the top line; with the dividers still at the line spacing as before, step off the spacing; with ruler and setsquare, rule.

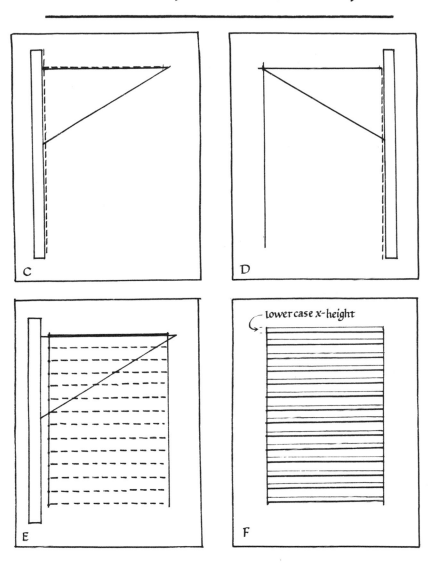

C

D

E

F

lower case x-height

Dividers: this tool is used to divide a line into a number of equal spaces, as in ruling a page. In this case, the spacing is determined by *the width of the pen's nib.*

" x height" 5 n w s
nib widths

rule space
3 xheight

Five nib widths give the letter height of the letters x, o or i, called xheight; set off this unit on the top line of the text; set the dividers' legs 3 xheights

apart; set one leg at the point that is the
intersection of the line already ruled as the top
line of the text block and the left hand, verti-
cal margin; step off the spacing down the
vertical length of the text area, say 18 times,
a standard number of lines to a page of script.
Do not press too hard: pressure can alter the
span of the dividers. These light pricks are
to mark the base line rules; to measure off the
top of the x-height above each of the rules,
step off the dividers from the top of the x-
height on the top row. Provided the span of the
dividers has not been altered at all, the result
will be a series of points, in pairs, pricked
down the left margin. With ruler parallel
to the margin, and set square, rule the page.

Ruling pen:

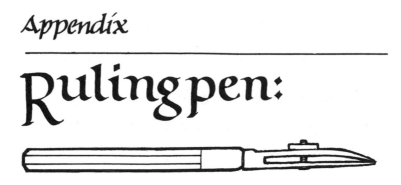

This, as the name implies, is a tool especially for ruling lines with ink. Ink may be applied with a dropper, or a brush. One drop is enough, and should be inserted between the blades of the nib. The screw controls the distance between the blade points, which determines line thickness: thinnest when closed, thicker when opened allowing a variety of effects. Provided the ink is contained within the blades, the pen nib may be drawn along

the edge of a ruler, even a non-bevelled one, or a set square, with no smearing or running of ink.

Also, the ruling pen usually comes with a compasses in graphic art or drafting suppliers; the ruling pen nib is detachable from its handle, and can be interchanged with the pencil-lead attachment of the professional compasses. This makes it possible to draw perfect circles in ink, as in the geometrically drawn letters of the alphabet; by a combination of ruling pen for the straight lines, and compasses for the curves, the alphabet can be drawn entirely with tools, as we have seen, pp.102–143, above.

Paper and Ink :

last but not least, for art and calligraphy
good paper is necessary. You need some
top grade paper, a few sheets of the best
make available, for very special work. But
for every day work you need a stock of
paper which need not be hand made,
sized, deckle edged or watermarked. You
can get a single-ply Bristol Board, acid-
free or 'P-H neutral', with a high rag con-
tent, which is quite serviceable and takes
Chinese (*non waterproof*), Indian (*water-
proof*) black inks; Tempera, Gouache, or
designers' colours. Spirit-based inks
may bleed on single-ply Bristol, though,
and water colour wash cockles this paper.

The best ink is the stick sort, a little finger
length of pressed carbon, bound in a med~
ium of gum. This has to be hand ground in
a slate slab, available at the supplier. A
few drops, less than half a teaspoon, in the
grinding stone is sufficient to dissolve the
stick into a strong, solid black; too much
water takes too long to blacken, as even a
few drops may need ten minutes to rub to
jet blackness. Alternatively, Chinese (or
Japanese) sumi ë ink comes in bottles,
ready to use. Indian ink is like Chinese ink,
but with lacquer added to make it water -
proof. Chinese ink is kinder to nibs and
brushes, and washes out when dry, be~
ing non~waterproof.

Appendix

While sumië ink is traditionally preferred by scribes, it is suitable for quill, or metal nib dip pens, but not for fountain pens. On the other hand, writing fluid for pens such as Osmiroid or Sheaffer, etc., which are commonly used by calligraphers, is generally either not light-fast, so the dye fades in sunlight, or is acidic, leaving an acid burn after the colour has faded; it also bleeds on paper where Chinese or Indian works fine.

Recently, a new fountain pen ink has been developed, Pelikan Fount India drawing ink for Fountain Pens..it is opaque, light fast, and waterproof, and seems less gummy than plain Indian ink.